Backside
of
the
Moon

Backside
of
the
Moon

Backside
of
the
Moon

Tango Gao

Skyhorse Publishing

Skyhorse Publishing books may be purchased in bulk at special discounts for sales promotion, corporate gifts, fund-raising, or educational purposes. Special editions can also be created to specifications. For details, contact the Special Sales Department, Arcade Publishing, 307 West 36th Street, 11th Floor, New York, NY 10018 or info@skyhorsepublishing.com.

Skyhorse® and Skyhorse Publishing® is a registered trademark of Skyhorse Publishing, Inc.®, a Delaware corporation.

Visit our website at www.skyhorsepublishing.com.

10 9 8 7 6 5 4 3 2

Library of Congress Cataloging-in-Publication Data is available on file.
Cover design by Edward A. Bennett and Kelly Zhang
Cover drawing by Tango Gao

Print ISBN: 978-1-5107-3511-8
Ebook ISBN: 978-1-5107-3512-5

Printed in China

No matter where we live on this planet, we can all watch and experience the Moon reflecting its light on us at night. Whether that light is full or teasing us with mere glimpses of its magic light, it is ever-present in our lives.

But this familiar, eternally recognizable face that we see every day also has a dark side—a twin—that we never ever see. It, too, is ever-present, but because the Moon never spins, we never see its other side. I have always wondered what mysteries there must be on the dark side of the Moon.

In my life, I have found that the Moon's duality is reflected in people, creatures, and experiences, too. No matter what we see on the surface or what is right in front of us, there is always the possibility of something else—the other side. We may not see it at first, but with little bit of imagination, a new possibility can always come to light.

For the last ten years, I've been obsessed with this notion of the power of imagination to see beyond and have used my imagination to bring some humor and hopefulness into this world. Shouldn't we all enjoy the mystery and magic of the backside of the Moon?

TANGo

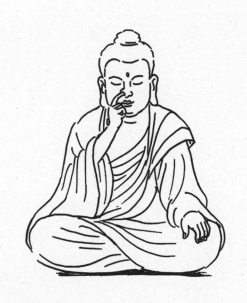

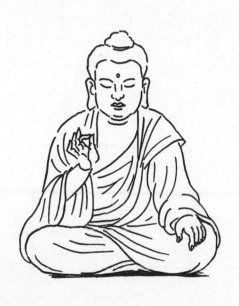

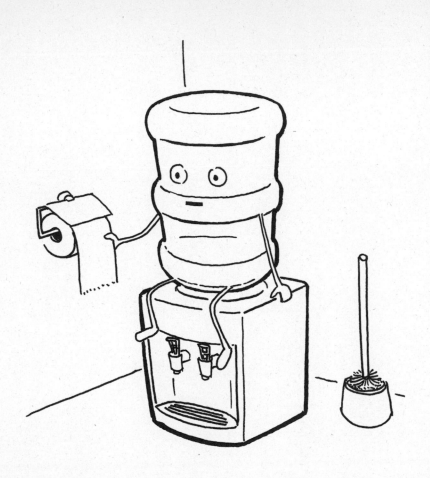

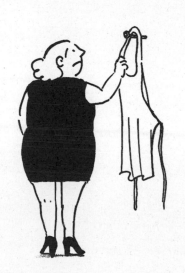
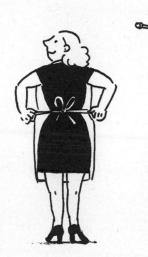

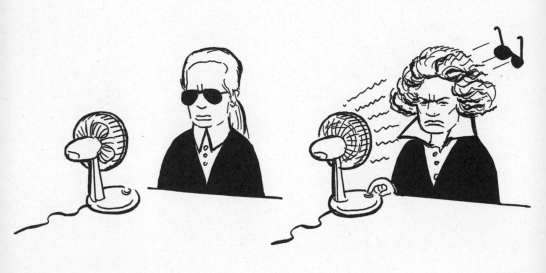

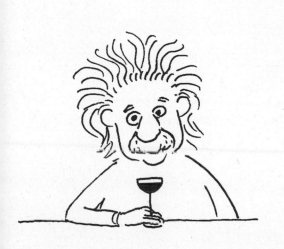
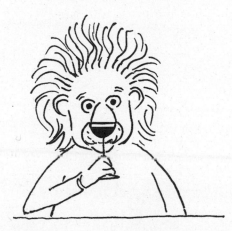

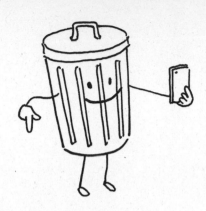

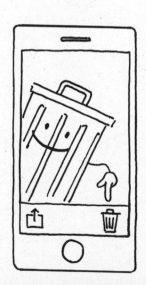

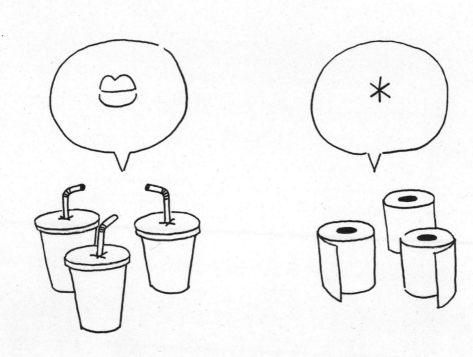

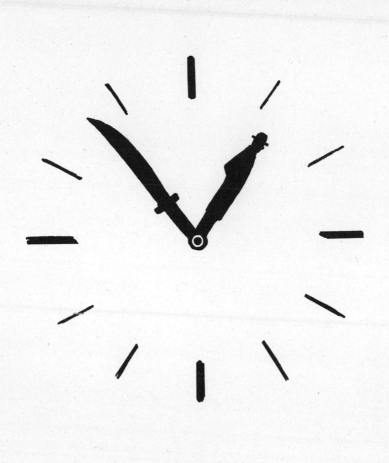

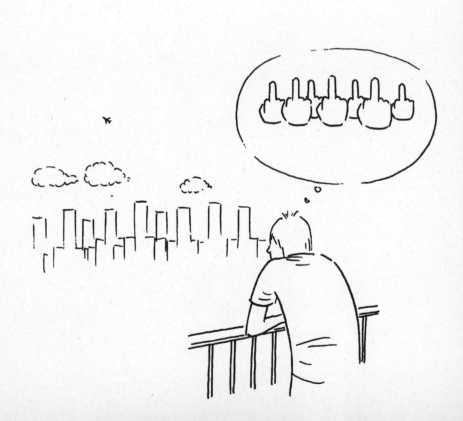

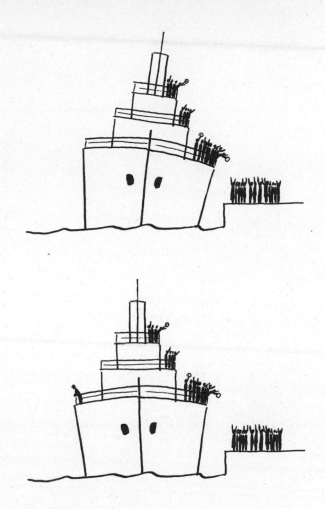

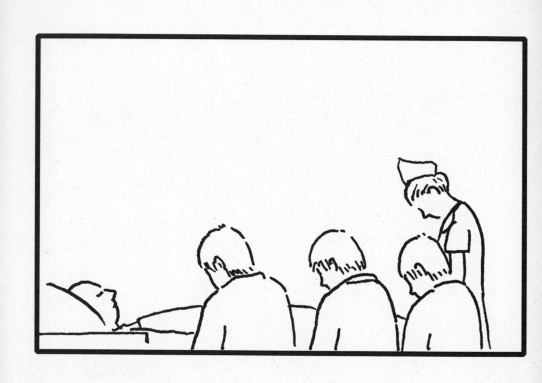

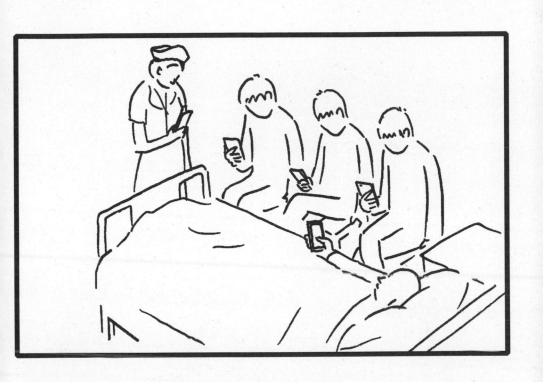

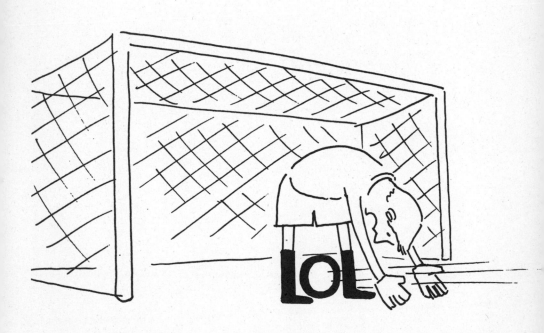

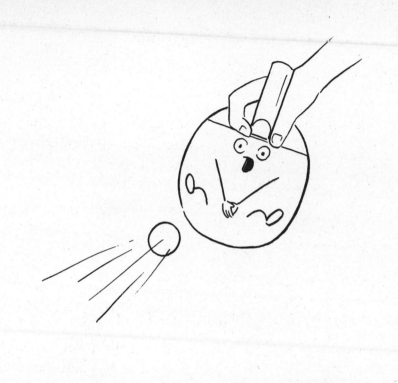

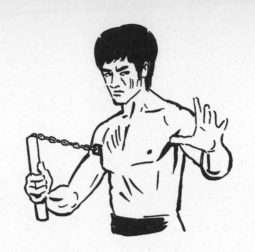

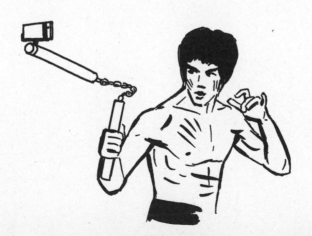

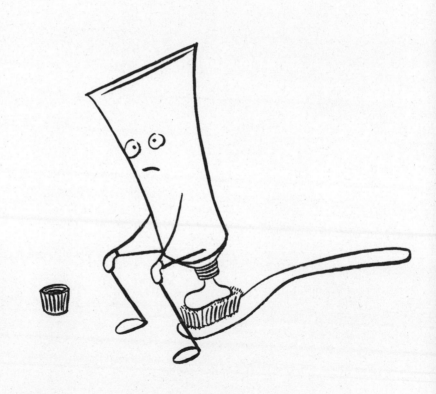

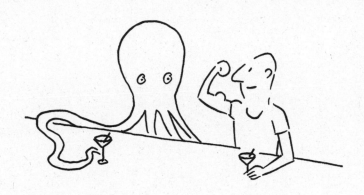

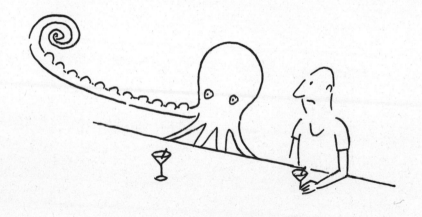

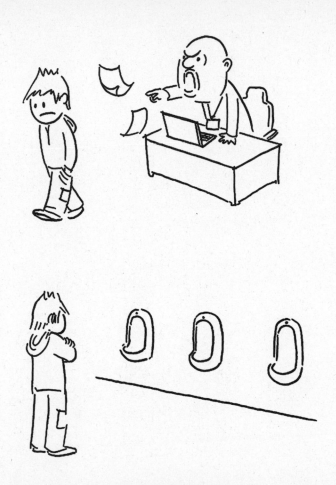

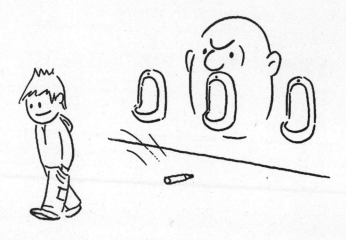

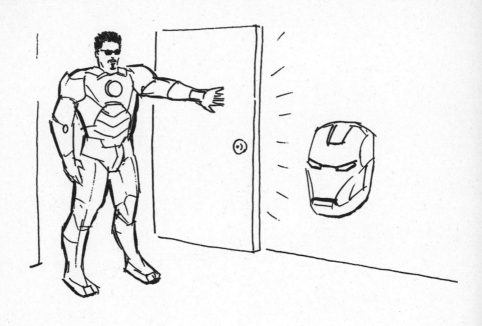

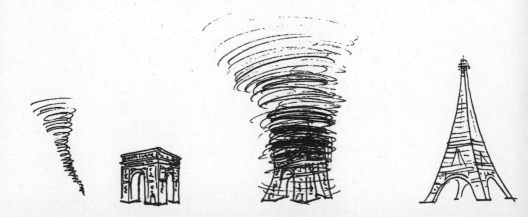

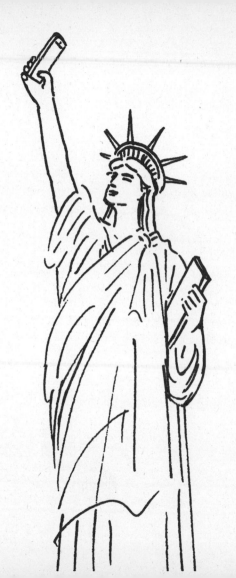

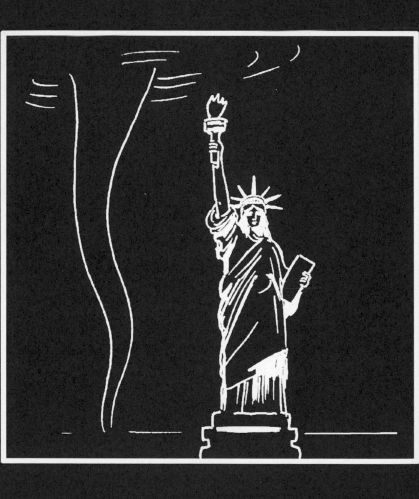

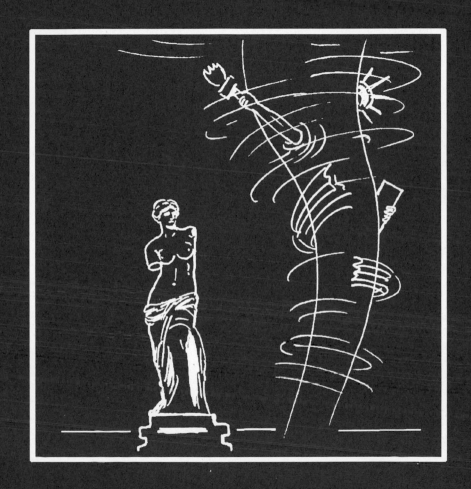

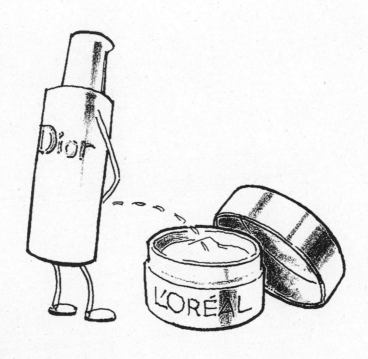

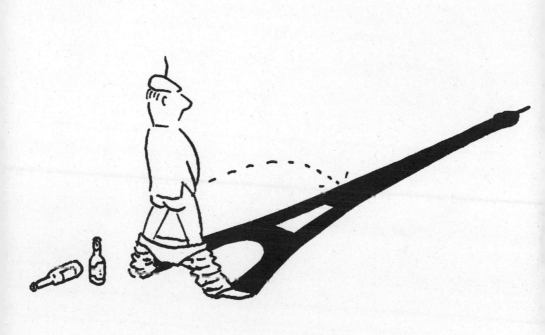

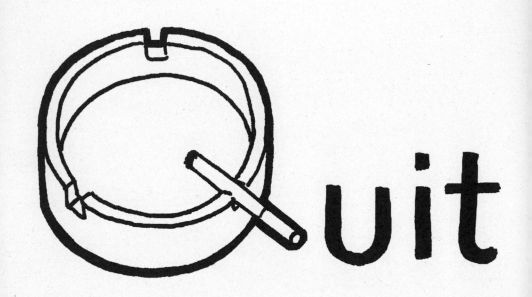

uit

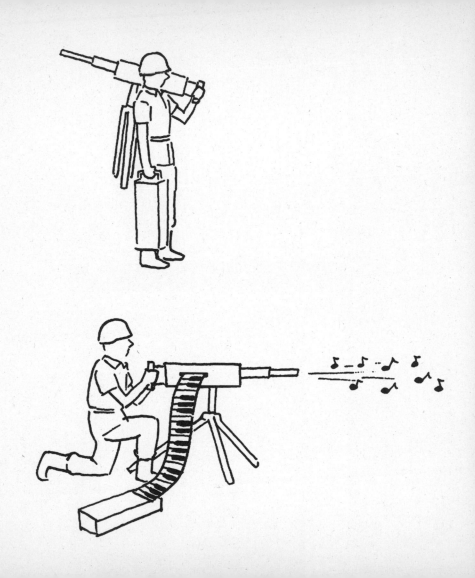

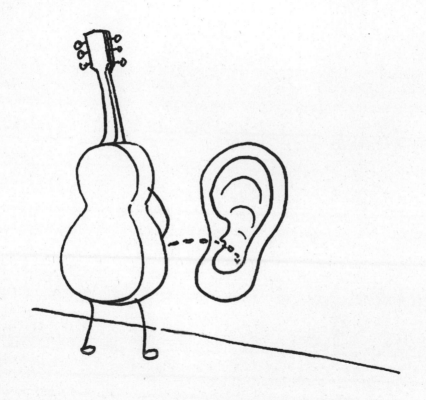

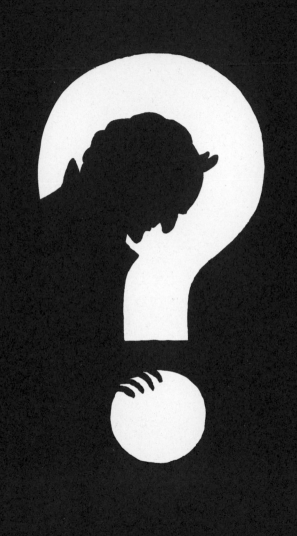

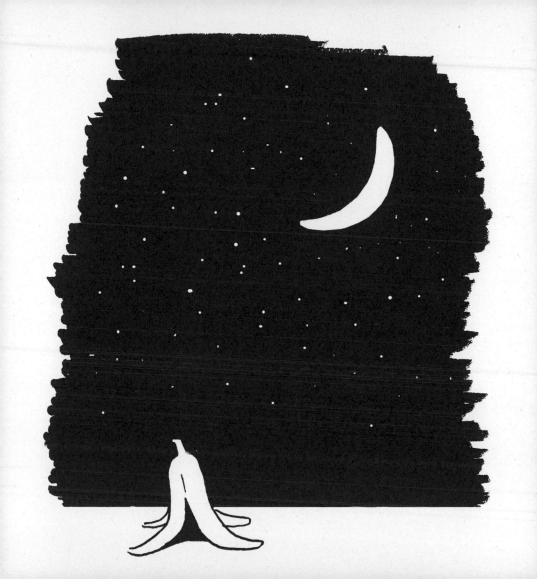

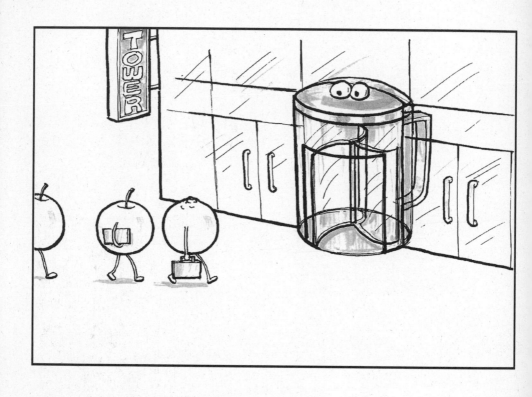

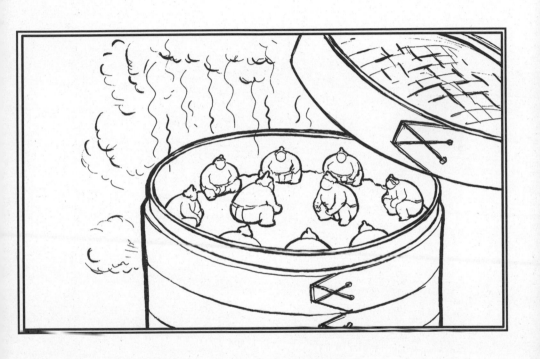

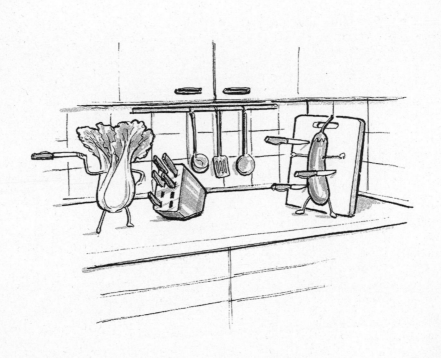

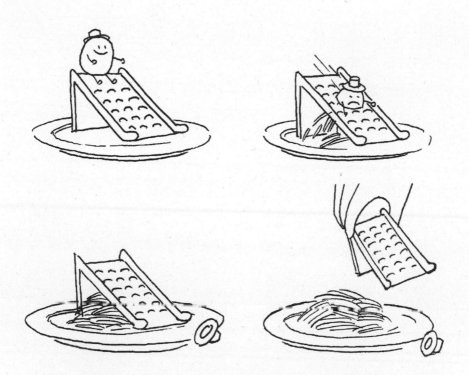

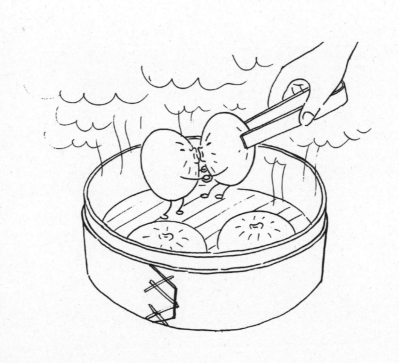

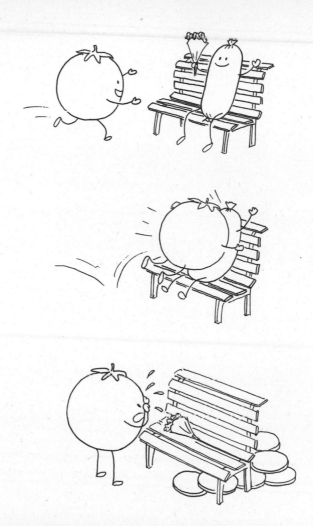

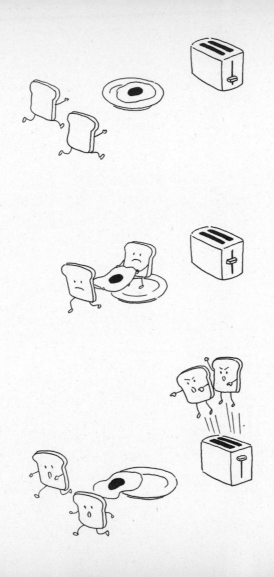

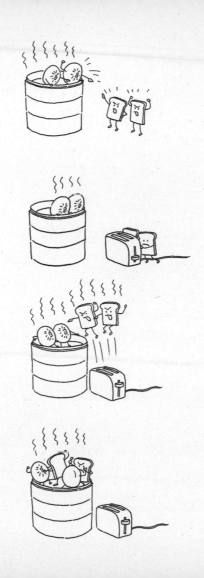

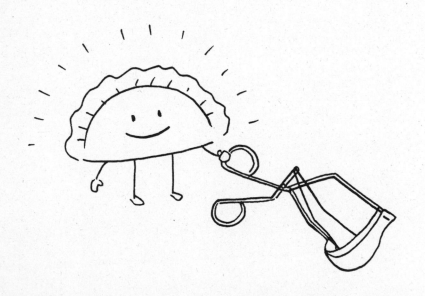

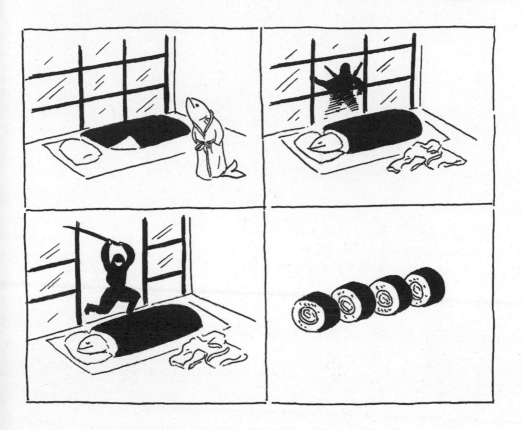

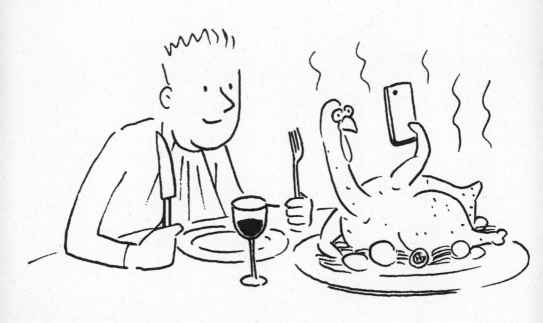

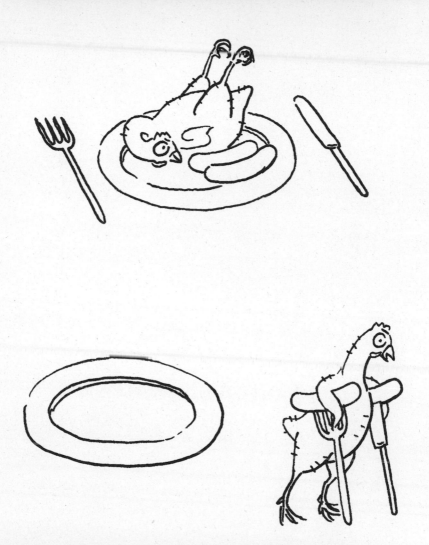

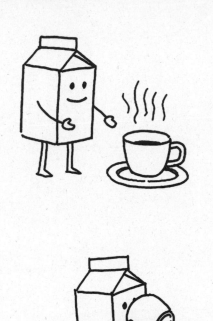

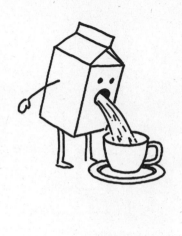

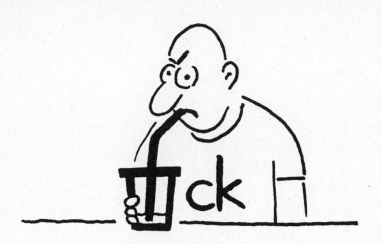

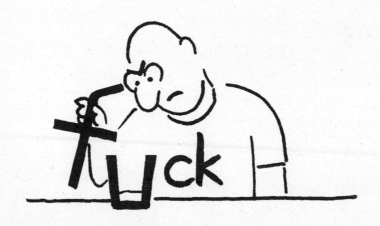

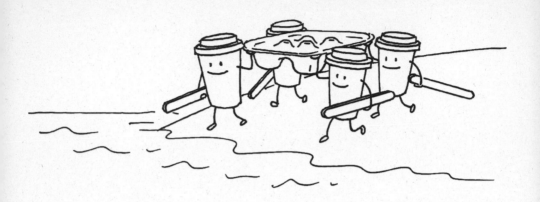

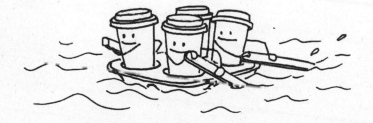

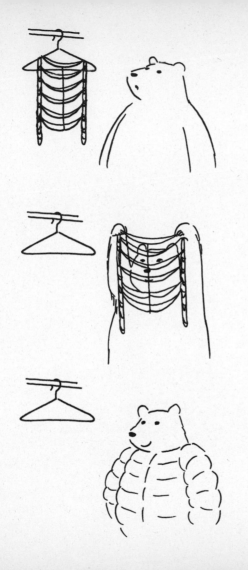

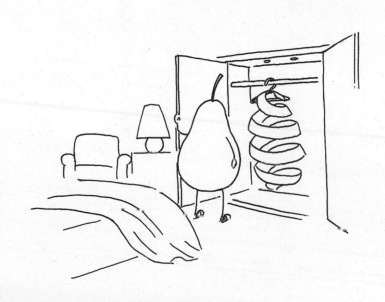

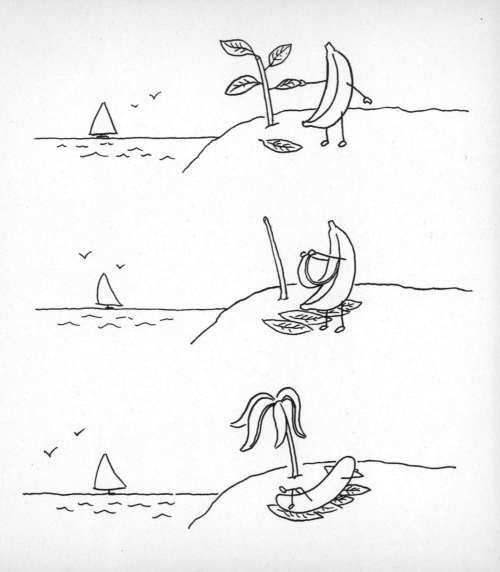

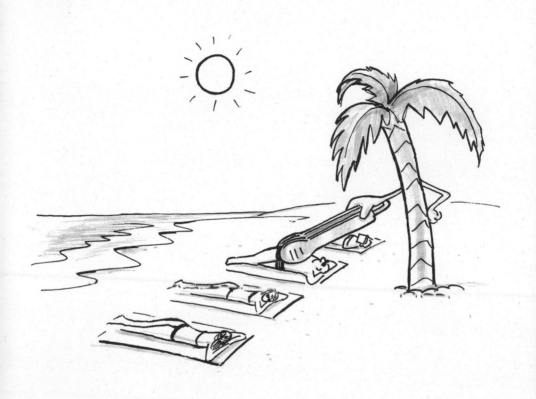

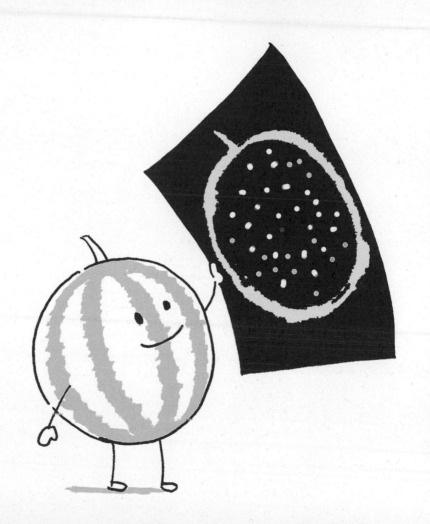

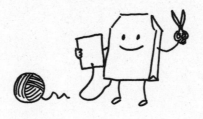

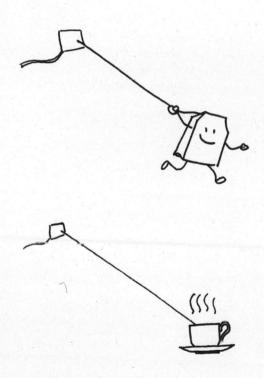

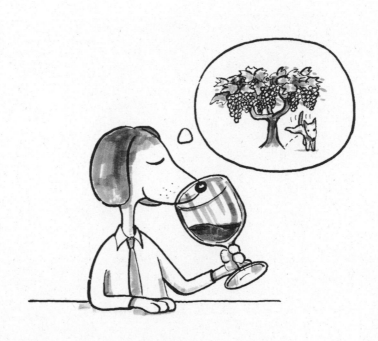

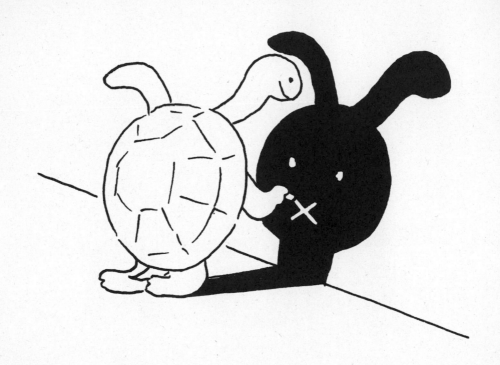

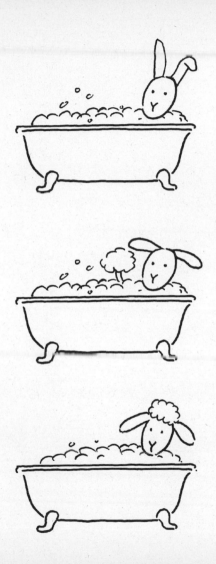

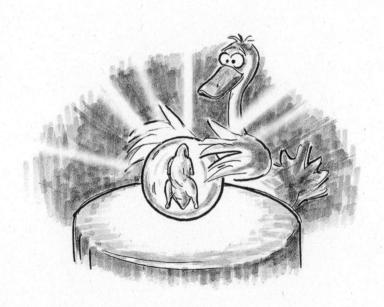

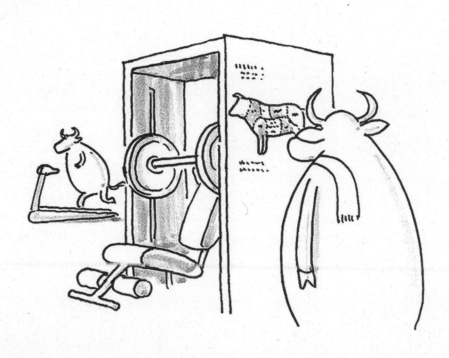

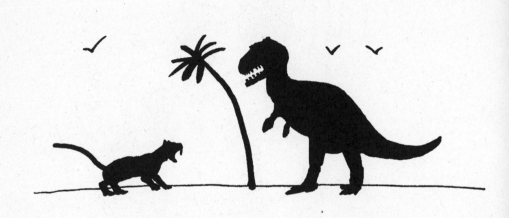

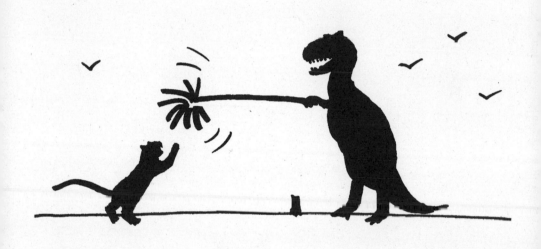

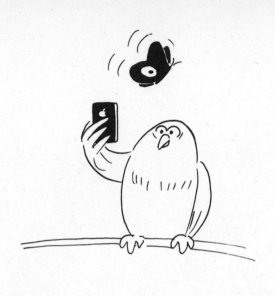

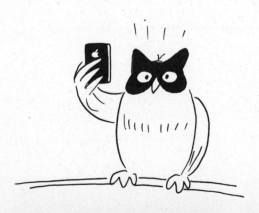

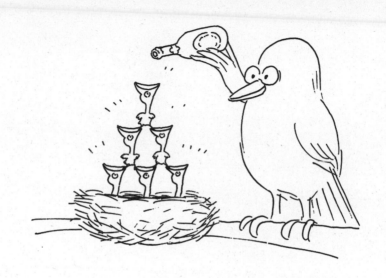

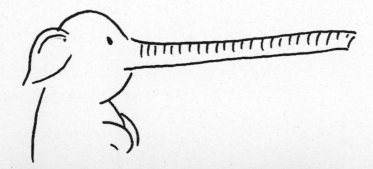

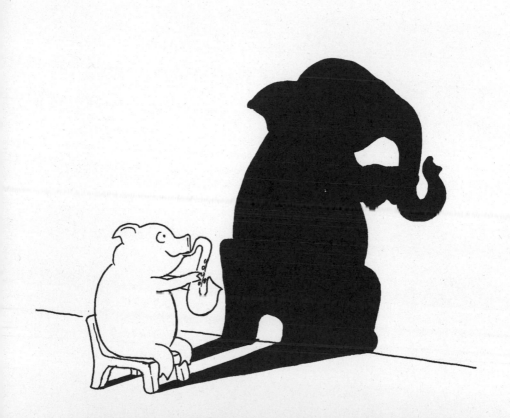

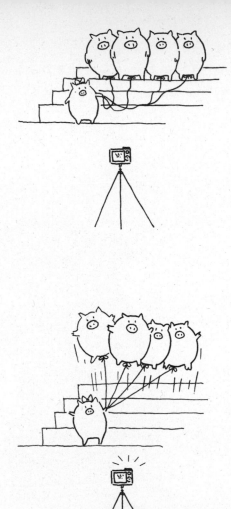

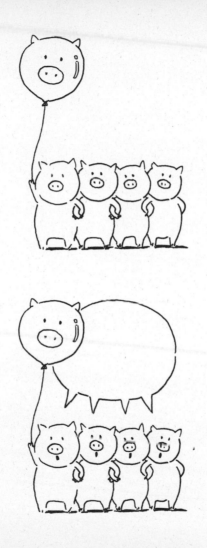

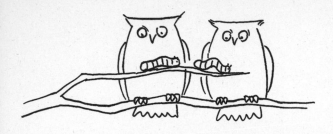

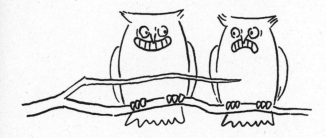

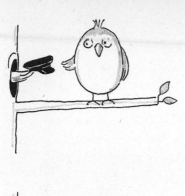

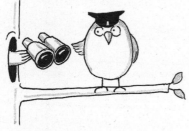

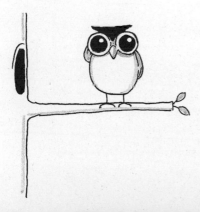

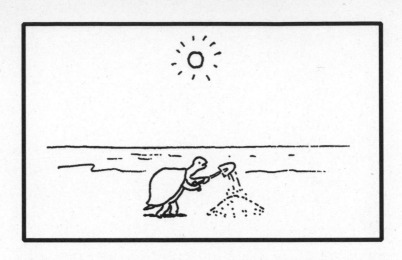

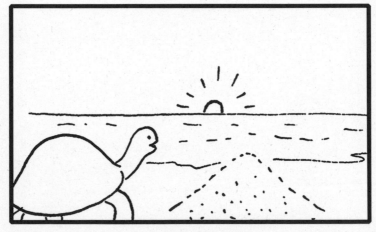

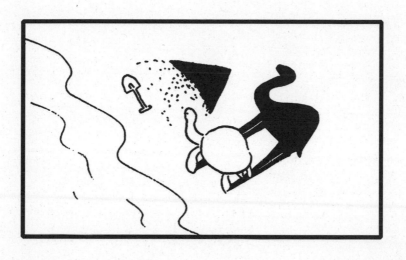

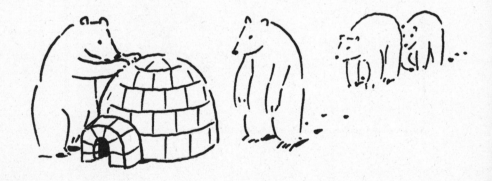

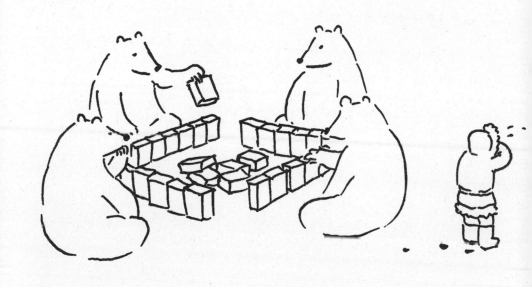

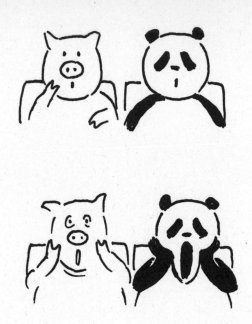

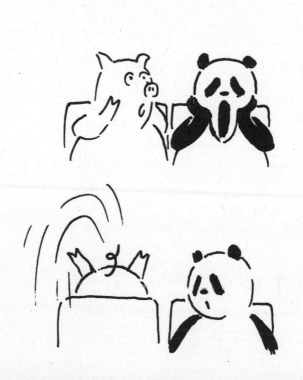

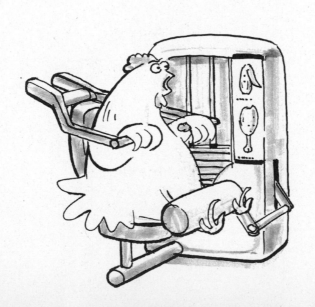

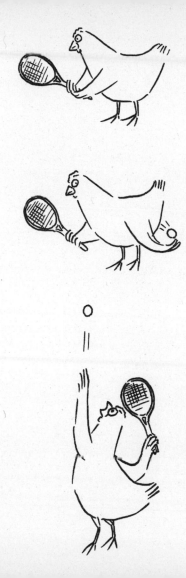

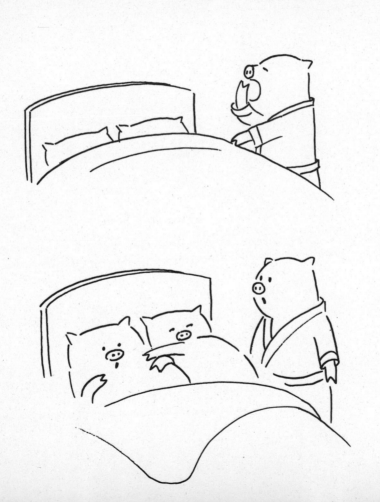

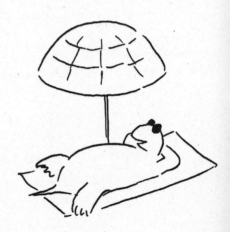

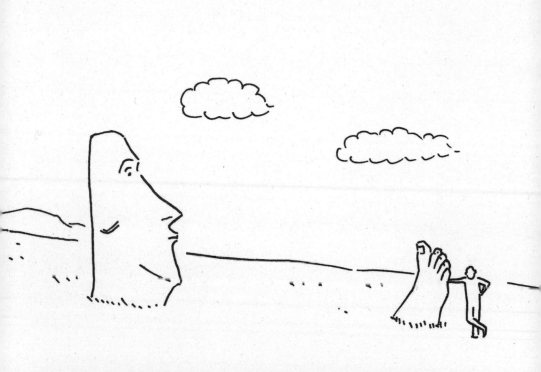

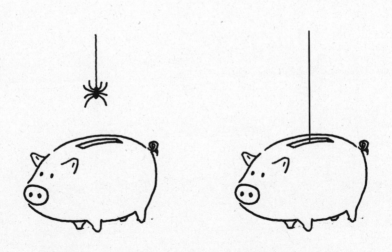

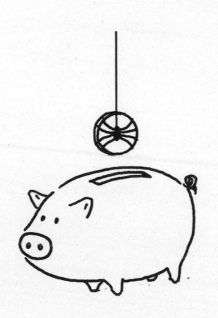

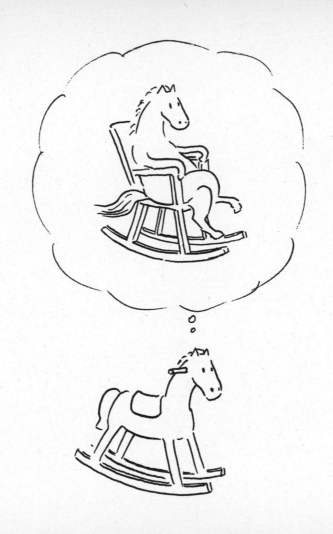

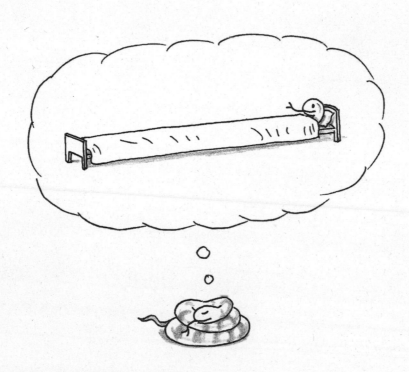

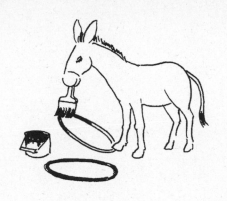

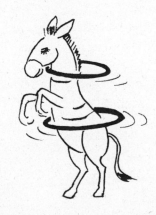

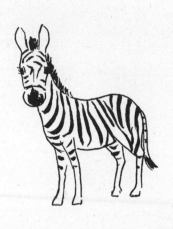

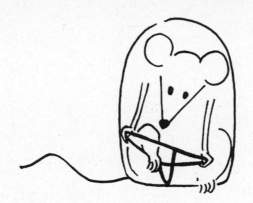

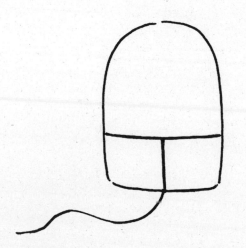

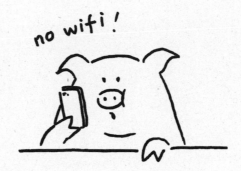

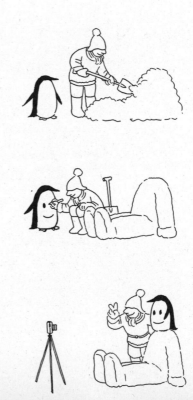

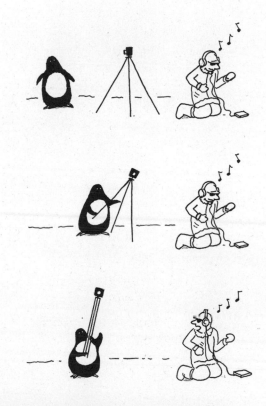

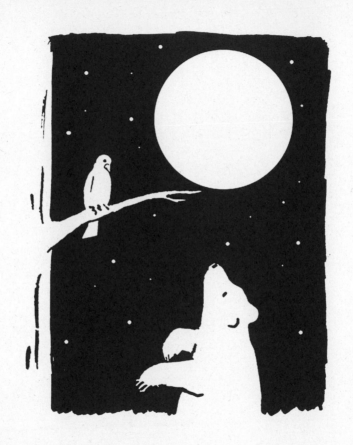

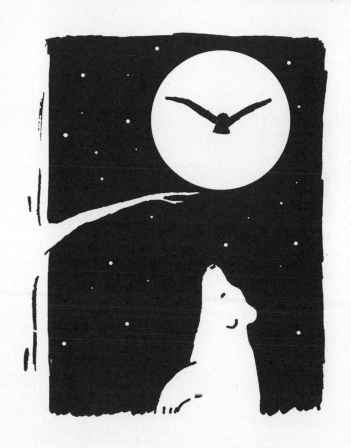

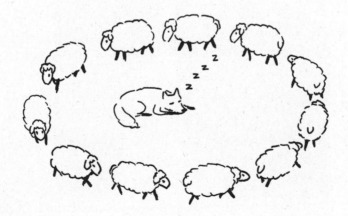

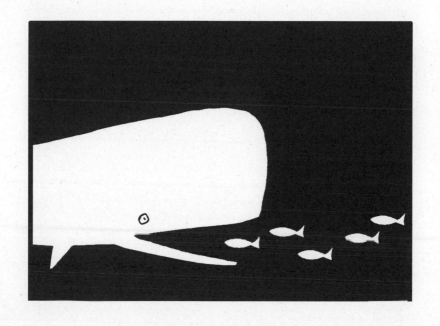

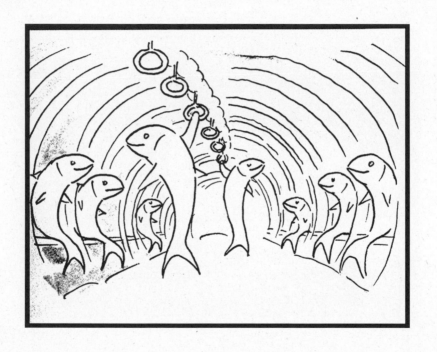

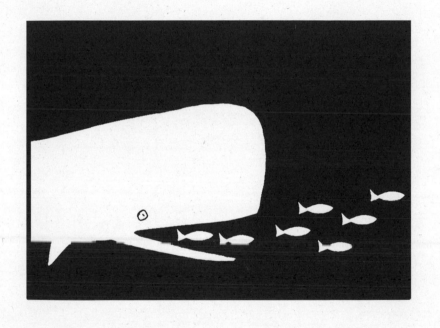

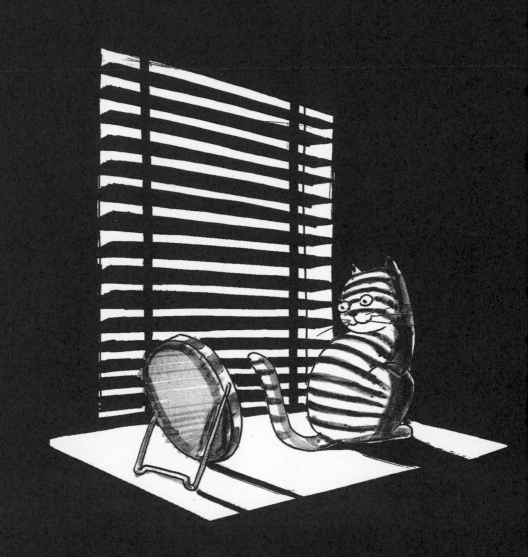

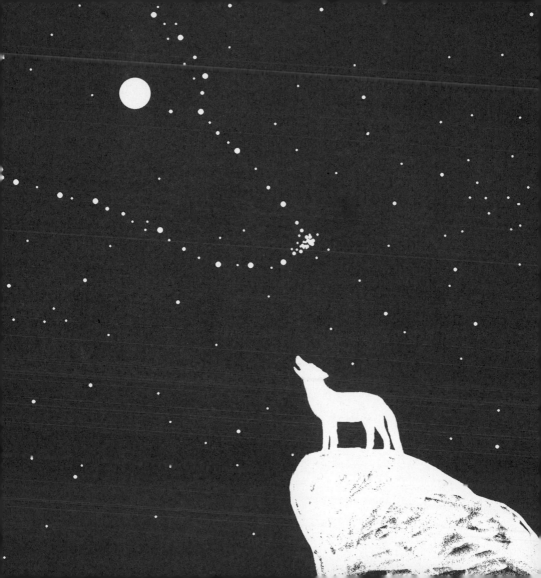

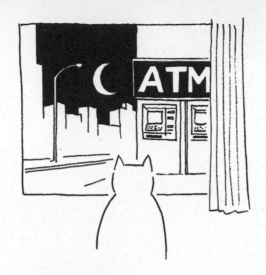

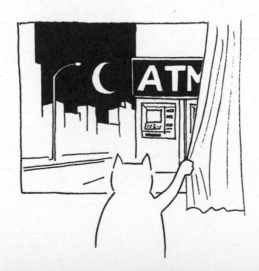

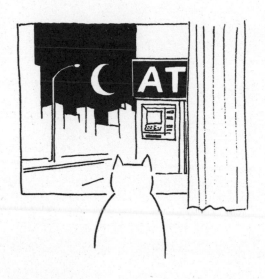

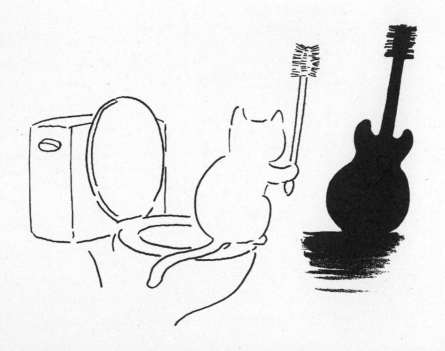

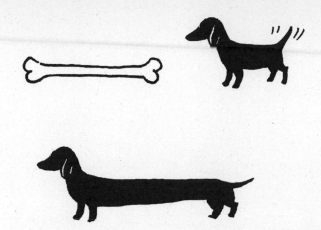

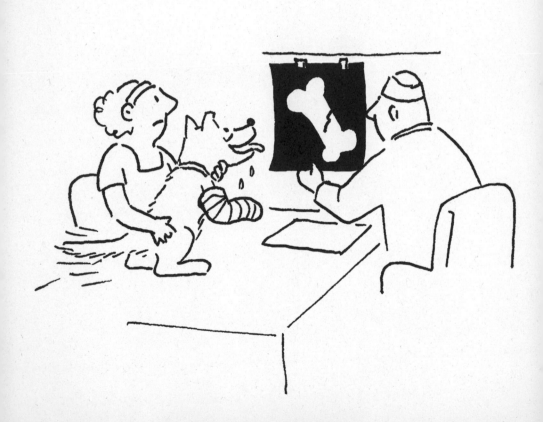

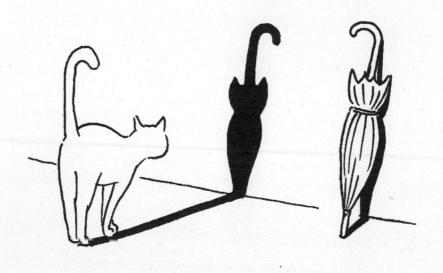

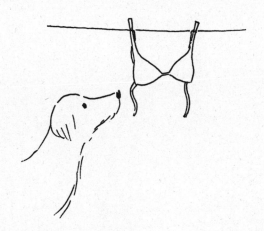

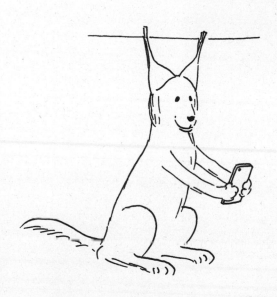

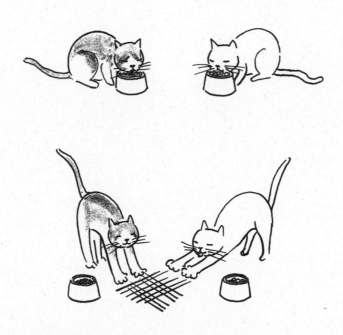

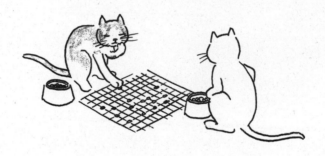

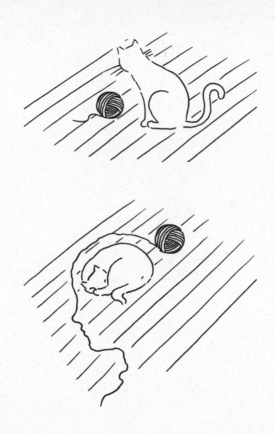

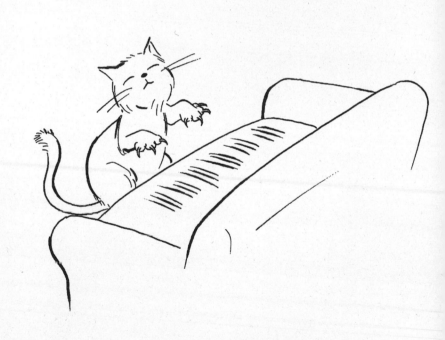

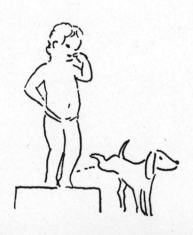

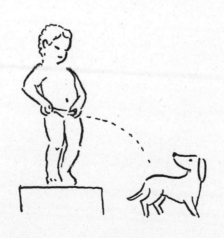

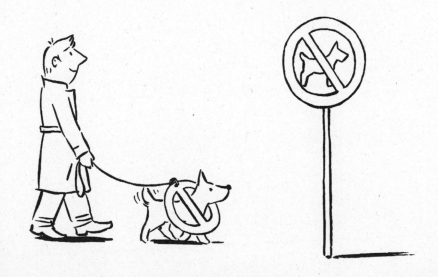

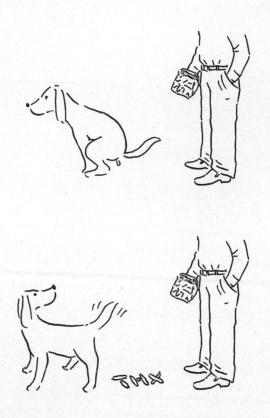

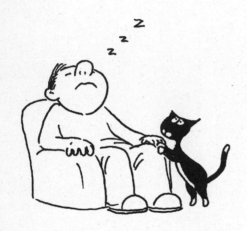

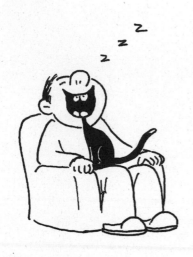

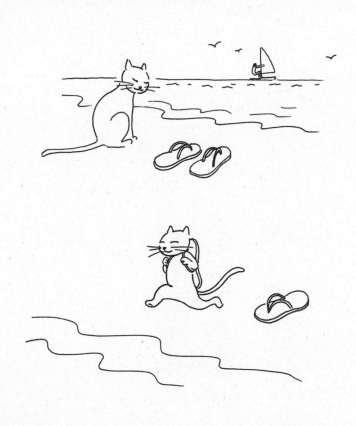

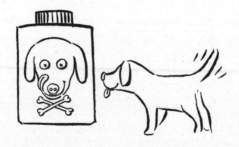

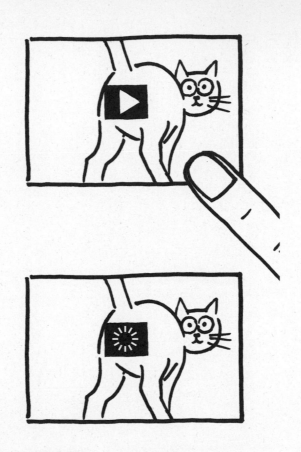

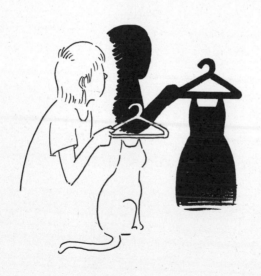

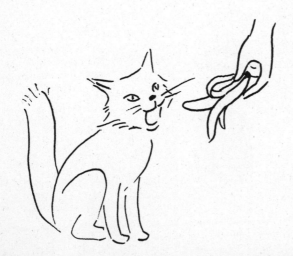

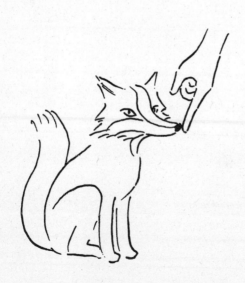

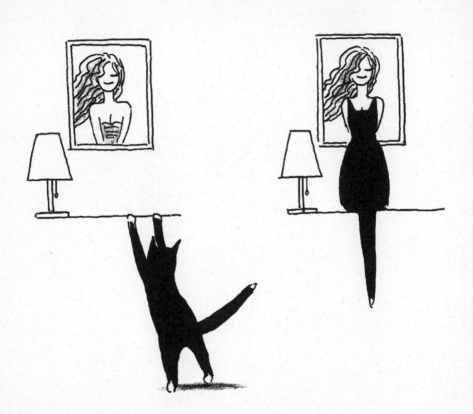

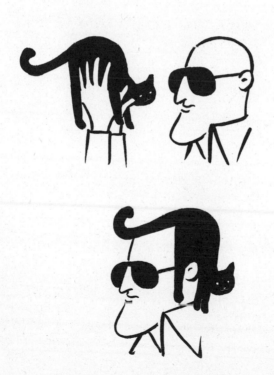

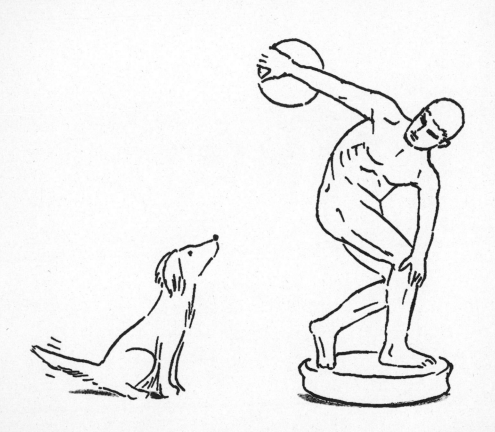

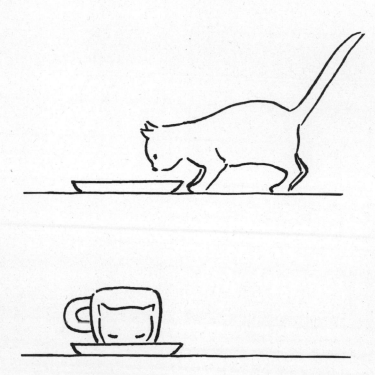

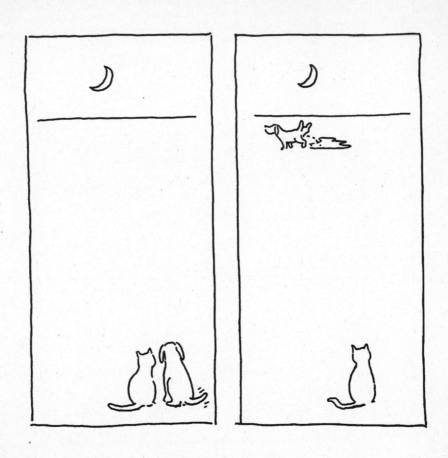

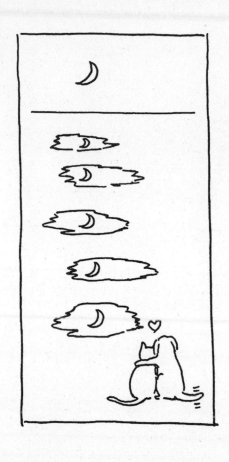

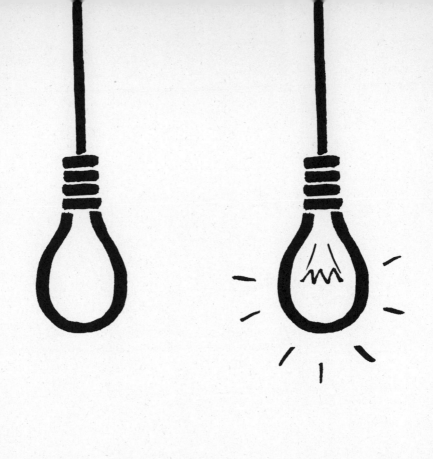

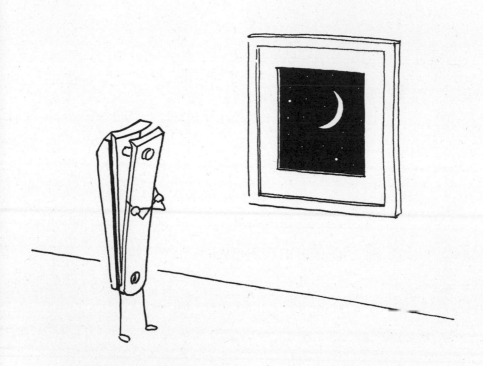

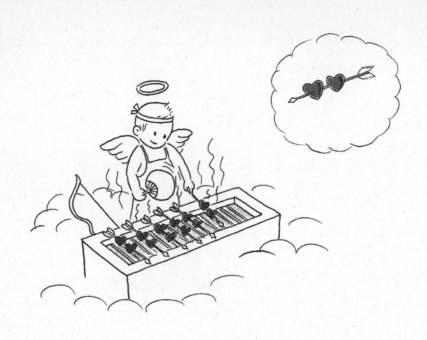

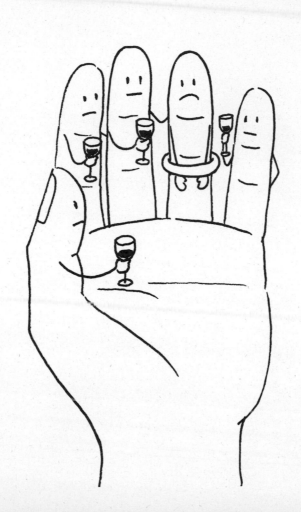

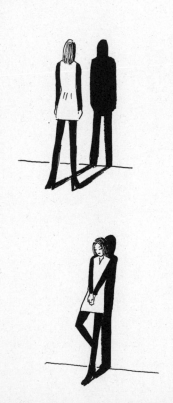

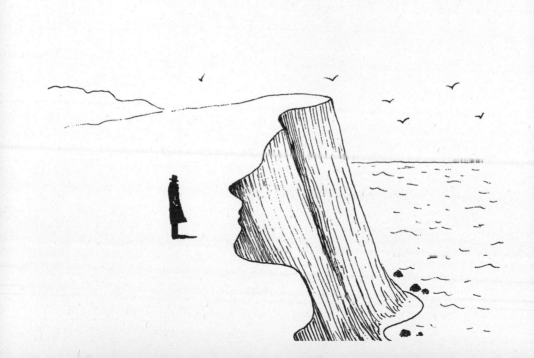

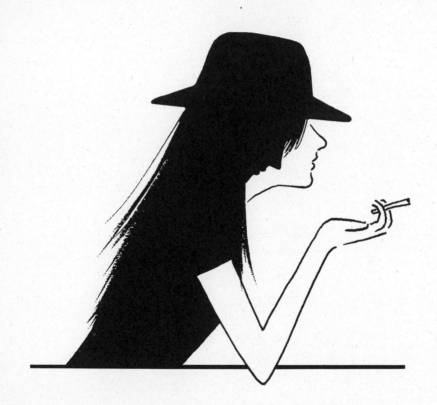

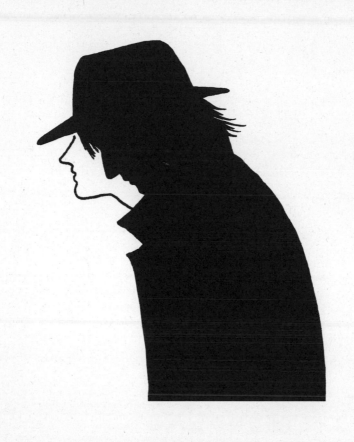

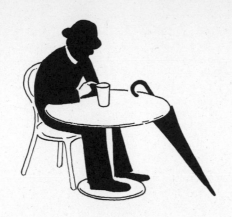

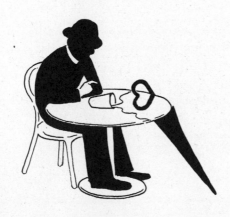

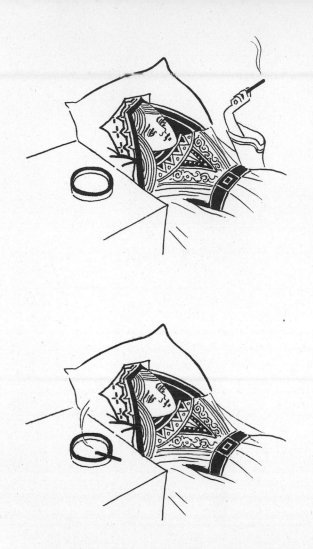

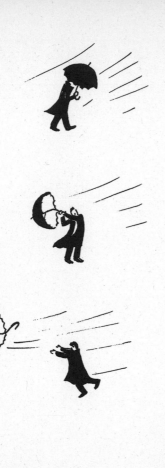
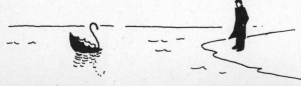

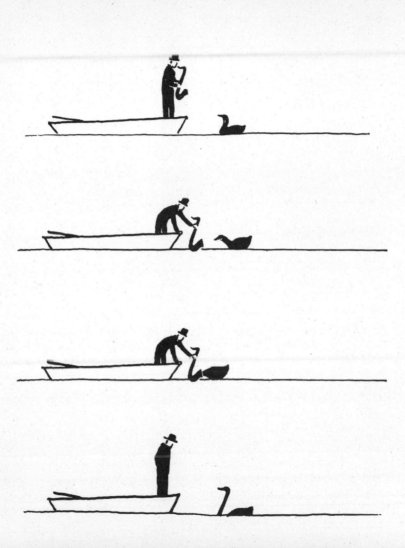

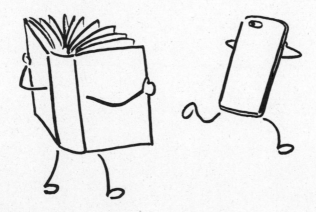

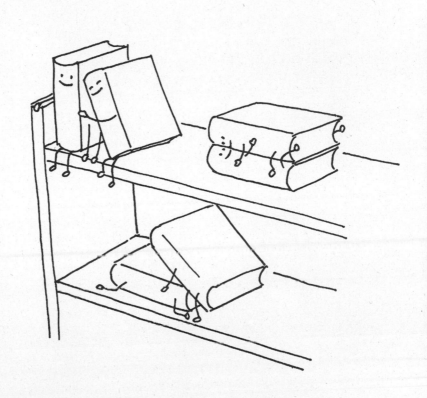

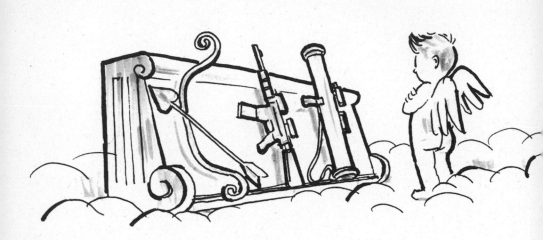

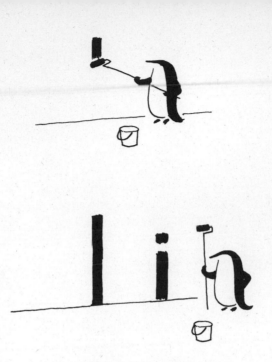

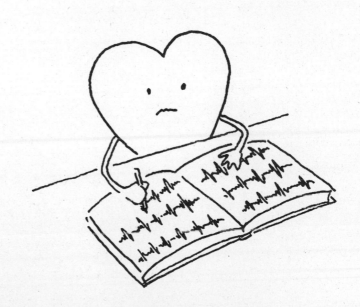

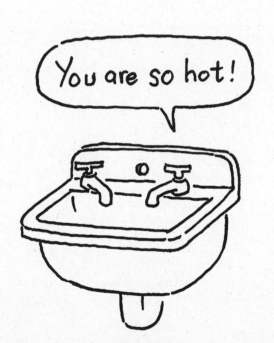

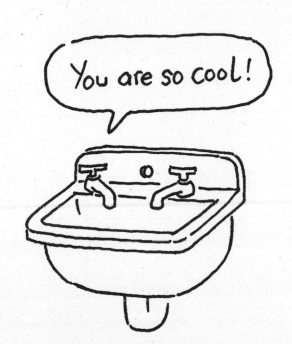

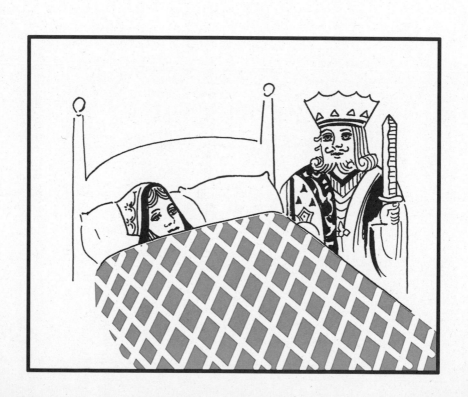

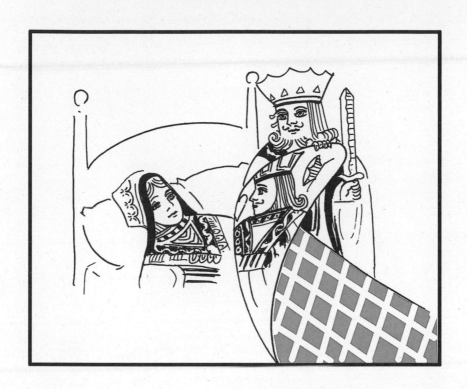

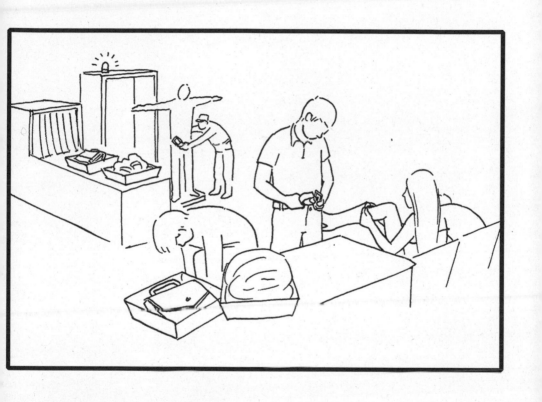

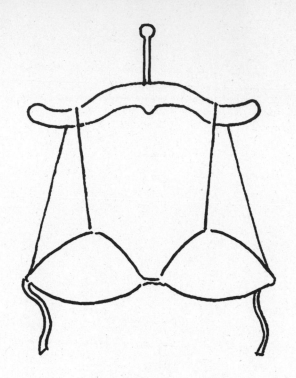

LiBRA

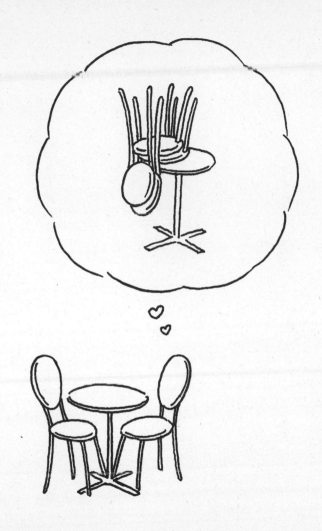

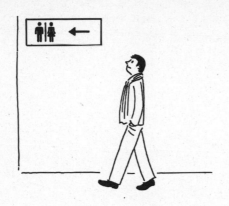

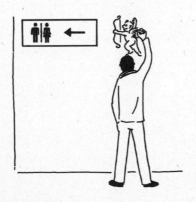

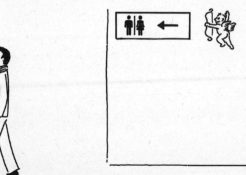

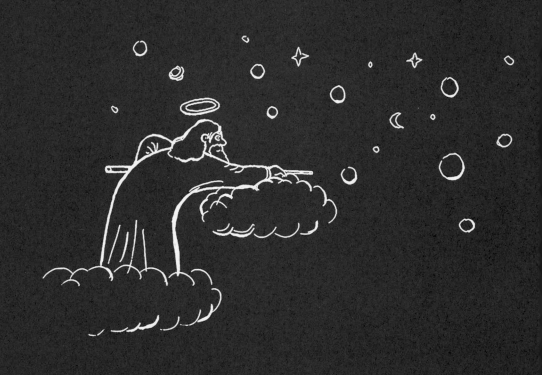

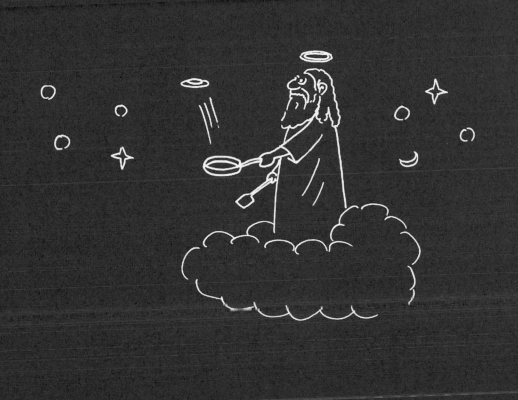

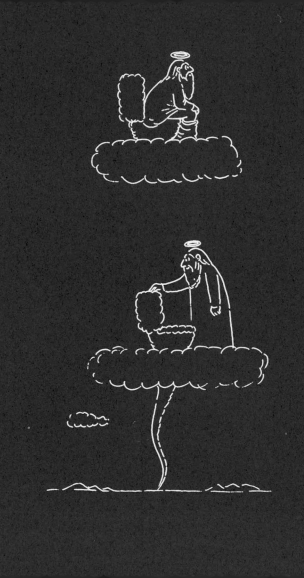

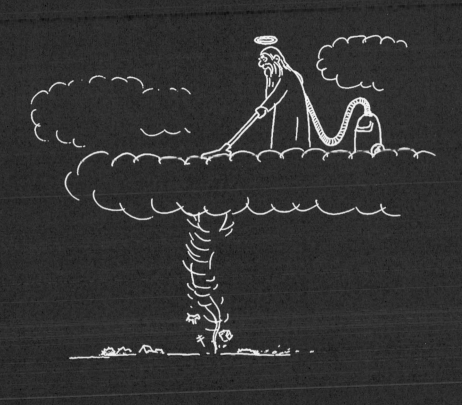

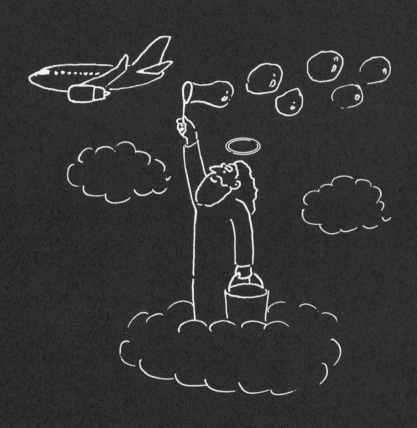

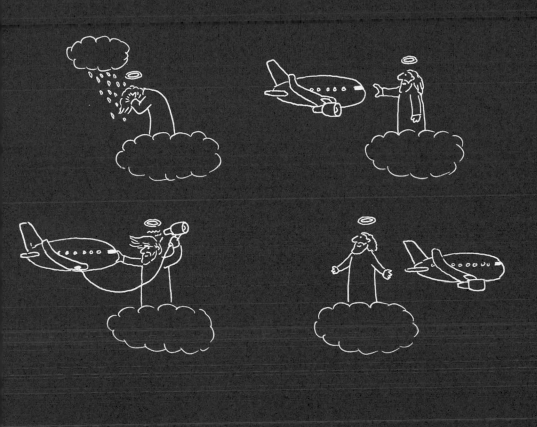

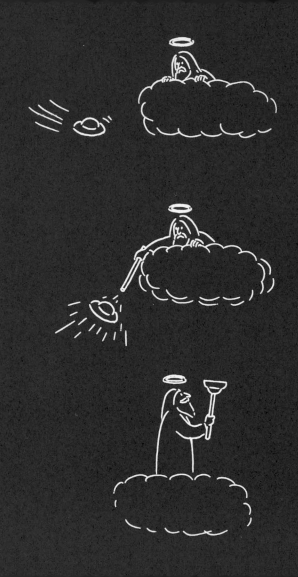

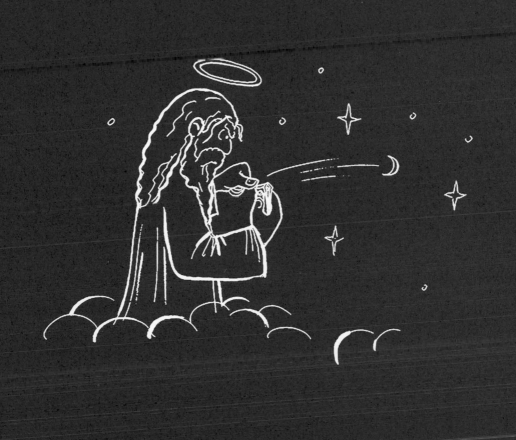

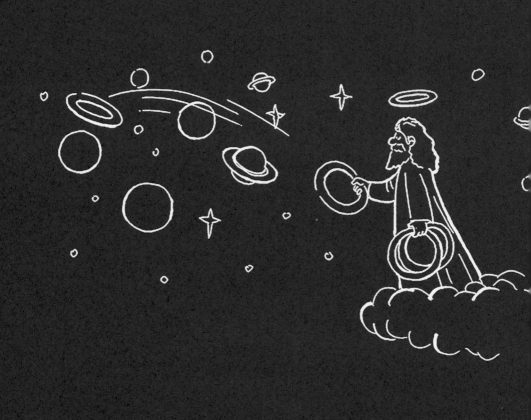

After graduating from the school of Mathematics at Shanghai Jiao Tong University, Tango, a Shanghai native, pursued his dream of studying art by completing a degree in design at the Academy of Arts & Design at Tsinghua University. He then entered the prosperous and competitive field of advertising. But art is where his heart lies. Tango's work is always deliberate, and his freehand stories speak in a lively, intuitive, and subtle voice. These days Tango divides his time between drawing and work in both Shanghai and New York.

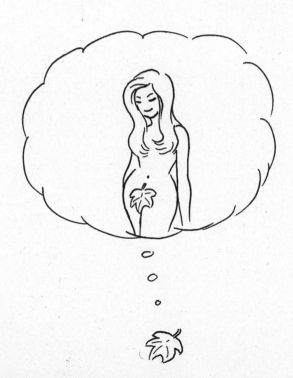